Folk Genre
Paintings

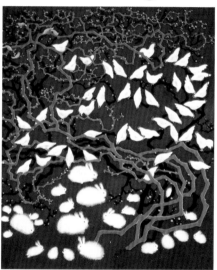

Edited by China Social Cultural Editing and Publishing Committee

Foreign Languages Press Beijing

"Culture of China" Editorial Board:

Consultants: Cai Mingzhao, Zhao Changqian, Huang Youyi and Liu Zhibin

Chief editor: Xiao Xiaoming

Members of the editorial board: Xiao Xiaoming, Li Zhenguo, Tian Hui, Hu Baomin, Fang Yongming, Cao Zhenfeng, Jao Yongfu, Wang Shucun, Yang Xianrang, Jin Zhilin, Hu Kaimin, Cui Lili, Li Cunsong, Tian Fuhui, Lao Chongpin, Yu Jian, Zeng Xiaotian, Wei Jianhua, Wang Hong, Zhou Daiguang and Lan Peijin

Translator: Yu Fanqin
Designer: Yuan Qing
Editor: Lan Peijin

First Edition 2002
Second Printing 2005

Folk Genre Paintings

ISBN 7-119-03028-0

© Foreign Languages Press
Published by Foreign Languages Press
24 Baiwanzhuang Road, Beijing 100037, China
Home Page: http://www.flp.com.cn
E-mail Addresses: info@flp.com.cn
 sales@flp.com.cn
Distributed by China International Book Trading Corporation
35 Chegongzhuang Xilu, Beijing 100044, China
P.O.Box 399, Beijing, China
Printed in the People's Republic of China

Folk Genre Paintings

Contents

Foreword

*Jiao Yongfu**

The two hundred and more paintings in this album were chosen from about ten thousand folk paintings done in recent years in various parts of China, so it is no exaggeration on my part to claim that they are the best. The aim in compiling them into an album is to give the art collector, connoisseur and general reader an opportunity to peruse the work of peasants, herdsmen, fishermen and housewives, familiar as they may be with the orthodox Chinese tradition, oils and graphic art; to take them into the mountains and the wilderness, to a world with a totally different charm and attraction from that of the secluded Palace of Art. It has also given us as compilers an opportunity to look back over the folk painting of recent years and to broaden our horizons.

In recent years folk painting has come very much into the foreground of cultural activities in China. One spring at the end of last century fifty-one counties notable for their output in the field were designated "Homes of Painting" by China Social Culture Bureau of the Ministry of Culture. Since then dozens of others have applied for the title on the ground of distinguished achievements, and investigation has shown each, whether or not the title has actually been conferred, to boast anything from a dozen to a hundred painters working in forms varying from ethnic folk painting to traditional Chinese painting, oils, graphic art and cartoon. This album includes paintings from sixty-six counties and towns, mostly those designated "Homes of Painting." The work offers a general picture of recent folk painting in China.

One may be forgiven for wondering whether the sudden boom in folk painting in China is financially motivated, but it is not. Although several exhibitions of Chinese folk painting have been held at home and abroad in recent years and some pieces have fetched large sums from connoisseurs, this amounts only to acknowledgement of the artistic value of the paintings rather than any avarice in the painters. In a nutshell, the prosperity of folk painting in China simply reflects government concern for the happiness of the people,

* Jiao Yongfu is chairman of the Chinese Folk Art Association.

resulting in a more affluent peasantry seeking beauty and artistic satisfaction.

In the 20-some years since the end of the 1970s, when reform and an open policy have been followed in China, a socialist commodity economy has developed and the people's livelihood greatly improved. At the same time the spiritual vista of the broad masses of peasants, herdsmen and others has undergone tremendous expansion and uplift. They are no longer passive listeners to songs and viewers of paintings by others. They want to participate in creative life themselves. They sing before audiences and take up painting brushes in search of the value of life and to demonstrate their talents. I dare say that when readers skim through this album of paintings in a variety of styles they will be forcibly struck by the rich imagination and varied expression of these peasants, herdsmen, fishermen and housewives.

Some may ask how such unsophisticated people, who have never so much as set foot in an art academy, come to paint so well. It is because they are close to production. They till the land, ride the vast plains, sail the rivers, lakes and seas and are intimately involved with nature, so that they have at their fingertips the rich material of productive activity, and this frees them from conformity. They paint their feelings or whatever they care to paint, freely, constrained solely by the need for fulfilment and tempted no further. This does not mean that they paint merely for their own enjoyment. On the contrary, they seek to reach out for sympathy. It seems that recently professional artists are increasingly interested in imitating and studying folk painting and that market traders are paying attention to its monetary value. Although this shows that this folk art form has acquired status in the eyes of professionals and laymen, it also causes unease that it may become mercenary and crude. Thus it was with mixed feelings of pleasure and anxiety that I urged the compilation and publication of this album and write this foreword, in the sincere hope that a book of the best in the field will not only draw attention to Chinese folk painting but also contribute to the preservation of its good name.

On Modern Folk Painting

*Cao Zhenfeng**

In an article l wrote l renamed what had been called "peasant painting" "modern folk painting" on the grounds of the trend of development and the new elements in peasant painting as well as the changes in the ranks of the painters.

Modern folk painting is at once ancient and young. lt is ancient because its mother body has an ancient history, one longer than any genre of painting; it is young because this particular genre of painting emerged less than thirty years ago. Although it embodies an ancient folk art form, it is totally free of staleness, has a vigorous artistic impact which is at once strong, sincere and bold. lts exaggerated modelling, distortion and surrealist treatment do not distort life but on the contrary give a feeling of truthfulness and closeness. Though colourful, it is simple and devoid of ostentatious pretension. Although its local flavour emits a light fragrance of mountain flowers in contrast to urban bustle and noise, it nevertheless conformsto the rhythm of modern life and meets the requirements of a new cultural level. lt possesses the fervour, simplicity and straightforward qualities of the labouring people. Rather than ostentaion and obfuscation, we see here the simple purity of childhood.

As one of the origins of art, folk painting is by no means

A training station in Sujiatun, Shenyang

an exotic on the artistic scene, and it is natural that in the last two decades it has blossomed anew in more and more provinces of China. It flourishes in the Liao and the Songhua valley in the northeast; on the Shaanxi-Gansu and Qinghai-Tibet plateaus and around the gobi in the northwest; beside the Yellow and the East and South China Seas; on the Zhongzhou Plain, the Jianghan Plain and the Xiang valley in Central China; and on the Yunnan-Guizhou uplands of the southwest. Beside Han painters are those of the ethnic minorities like the Manchus, Huis, Tibetans, Koreans, Yis, Yaos, Uygurs, Miaos, Tujias, Bais, Hanis and Bouyeis. And the varied regions and ethnic groups from which the painters come account for the regional and national diversity of folk painting. Already in the 1970s the peasant painting of Huxian County in Shaanxi Province was known for its vigour, simplicity and typical Central Shaanxi flavour. Later the peasants of Ansai, Luochuan and Yijun were distinguished for their rich folk-art tradition and bold, mystic, strong and intrepid impact. The folk painting of Jinshan in greater Shanghai is characterized by scenes of fresh, tranquil Yangtze villages.

* Cao Zhengfeng is vice-chairman of the Chinese Folk Art Association and vice-curator of the National Art Gallery.

The decorative Weifang new-year poster infuses painting of Linqu and Rizhao in Shandong. The style of Wuyang in Henan is straightforward, while that of Hami and other parts of Xinjiang depicts Islamic customs and habits. Liaoning and Jilin strive for a realistic depiction of the villages and snowy forests of the northeast. The style of Huanggang in Hubei and of Longhui in Hunan recall the culture of the ancient state of Chu. The style of the Miaos in Guizhou evokes their mystic past. Paintings from just north of Tianjin are either highly exaggerative or strongly rural. Longmen in Guangdong shows us the southern land, while the fishermen of the Zhoushan Islands in the East China Sea are as capricious as the raging surf.

The themes of modern folk painting are basically the customs, habits and legends and work of the various ethnic groups of China, with changes emerging as new aesthetic standards influence tradition. Although artistic styles differ from place to place, they are all intensely local and reflect the feelings of the labouring people. Where other artists may follow the modern Western vogue, departing further and further from everyday life, modern folk art sticks close to the land. Quality aside, modern folk painting has always followed its own path in creative awareness. Its history, though short, has been tortuous. It was in the autumn of 1958 that the first peasant painting from Pixian in Jiangsu which appeared in a Beijing art exhibition received favourable press reviews. In their enthusiasm for national and local construction the peasants had with clumsy elegance sketched *The Monky King Comes to the Fiery Mountain* and *Maize as High as the Sky*. They believed in the miraculous, that maize could block air routes and backyard furnaces form new Fiery Mountains. Shulu in Hubei and Huxian in Shaanxi made their names at about the same time. The spontaneous expression of the peasants' feelings in paint was understandable, but painting itself had been artificially boosted and led astray when everyone was called on to paint and urged to cover every wall with painting and poetry. The wishful thinking in output never came true. When economic boasting abated peasant painting and poetry plunged to a low ebb, except in Huxian, where peasants persisted in using murals to encourage rural work. Thus hundreds of peasant painters were trained, and a new style emerged.

Peasant painting needed improvement and development. It needed to have its own language and form. These had long been problems. Well-meaning artists had tried to train peasants in Western art teaching methods in order to lead them on to a "scientific" path. The results were not satisfactory. In some places peasants were coached in

An art centre in Zhejiang organizes a meeting for painters to exchange experiences

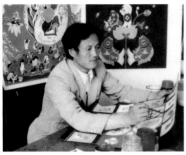
Wen Zhongli, a peasant painter in Liaoning

techniques used in the literary circles. This was a dead end, since the peasant aesthetics were different from those of the literati. Only in the late 1970s, bewildered by his many failures in coaching peasants, did Jinshan painter Wu Tongzhang discover that the countryside had its own store of folk art resources. Many village women were skilled embroiderers and papercutters. During the slack season they embroidered hats and clothes for their children. Others modelled for their own needs. He urged them to paint freely, using colours as they would thread. Their hands, more accustomed to the pick and the hoe and to needle and thread, were at a loss with the brush and the palette, but after a short period of practice and patient coaching, real peasant painting blossomed, and the energy of folk art, pent up for thousands of years, was finally released. The Jinshan exhibition in the capital astonished the art world.

The changed face of peasant painting dispelled the biased belief in its inferiority. More importantly Wu Tongzhang had discovered the hidden treasure of folk art and blazed the trail to modern folk painting. Painters in other parts of China copied and improved on Jinshan, which was uniquely

necessary if modern folk painting was to emerge and prosper. The ranks of modern folk painters have swelled to include herdsmen, fishermen and students as well as peasants proper, and it would be unscientific to define the painting by the painters' occupations, to remain calling it peasant painting, though this is a minor issue. What is notable is that although modern folk painting has developed from traditional national folk art, it is not a growth from the original plant but a genetic manipulation of many kinds of art, the result of meticulous cultivation. Retaining the characteristics and qualities of the mother body, it is yet different, an unprecedented flower of art cultivated by artists with modern training working at grass-root level, excavators and conservationists of traditional folk art discovering and acknowledging on a new cultural level the academic values and artistic rules of a folk art overlooked for thousands of years. They make accessible an art handed down through generations, cull the methods of papercuts, embroidery, batik and painting and refine them. This assistance and cultivation are extremely significant. Although peasants are the creators and heirs of folk art, the limitations of their cultural background have restricted them in absorbing new aesthetics and formulating laws. Even after historic changes in their lot they fail to conform with the aeshetic trend. Folk art is mostly for self entertainment devoid of commerciality. It needs transformation to enter the cultural market. Folk art is extremely fragile, having been looked down upon for thousands of years. People are prone to give up the tradition

under the assault of a new cultural environment and with the transformation in economic and living standards. We must never forget the selfless dedication of field workers who have enabled this neglected national treasure of art to blossom in a new form and unknown labouring artists to achieve recognition.

Of course some coaches are less successful, and some centres do not progress as rapidly. Correct method and adequate attention to the tradition are needed for success. The coaches need to give peasant, fisherman and herdsman painters confidence in their artistic talent and inspire them to improve their powers of expression and to master technique. The coaches must never run the whole show themselves.

Strictly speaking, peasant painting did not originate in Pixian, Jiangsu. Finding out its distant history is difficult. More recently peasants in northern Shaanxi have a tradition of auspicious new-year posters to decorate their cave dwellings, hand-painted new-year

A studio in the Jinshan Peasant Painting Society

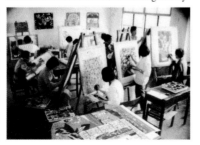

posters are found at Spring Festival markets in Hebei and Shandong, and peasants in Fujian and Jiangxi like to paint on their whitewashed walls. During the war years soldiers of peasant origin painted the lives of their comrades-in-arms between battles. Much of this work appeared in newspapers, magazines and company bulletins, as is proved by the amount still extant. It was all done in a national style with the simplicity of folk art; it was merely not regarded as a genre at the time.

Nevertheless, the peasant painting of the past is not on a par with modern folk painting, the most important distinction being that modern folk painting has organically absorbed the essential folk language of embroidery, batik and papercuts as used on clothing and during festivals. The modelling and designs of peasant painting are not solely aesthetic decorations but symbolic wishes for luck, good marriage and sons, respect for ancestors and religion and charms against evil. Recreated by many, these became highly refined in expression but never an artistic language to be appreciated. This is what modern folk painting has begun to do. Rather than a reproduction of embroidery, papercut and batik, it is a new art form and a new channel of folk expression, showing that the artistic tradition of the people has great vitality, not simply in this art form, but as the mother body and origin capable of generating a newer and more artistic flowering of the modern national spirit. It also proves that the labouring people who create material culture, have phenomenal ability to create mental culture too.

We can foresee a bright, peaceful spring for folk art. The industrious hands of the people are turning a brilliant page in folk art.

In 1977, painter-coached village women in Jinshan of Shanghai excelling in embroidery substituted paper for cloth, paint brush for needling, pigment for silk thread and painted whatever they fancied in their own composition. Since then, modern folk painting has flourished in Jinshan.

Sailing Boat 62 × 55 cm Shao Qihua from Jinshan

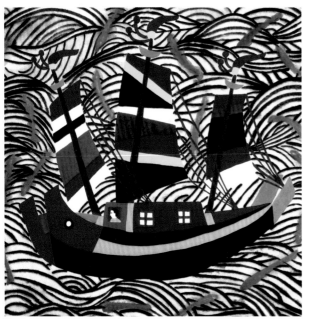

Raising Chicks 57 × 57 cm Zhu Suzhen (female) from Jinshan

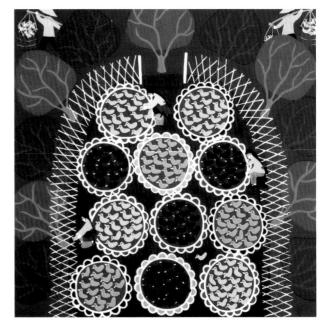

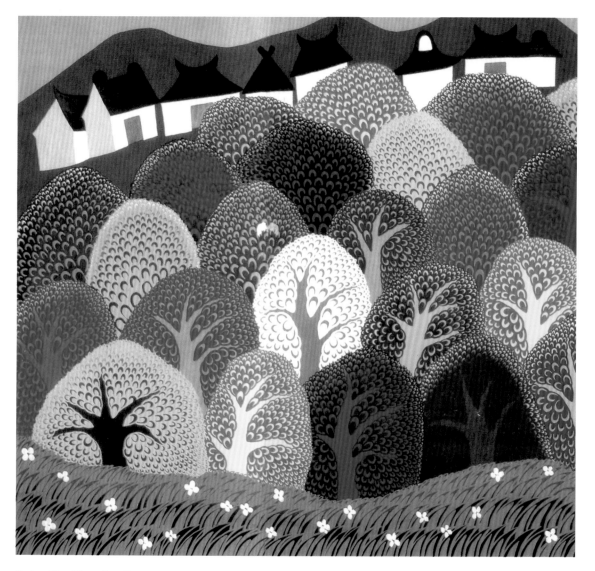

Spring 67 × 65 cm Cao Xiuwen (female) from Jinshan

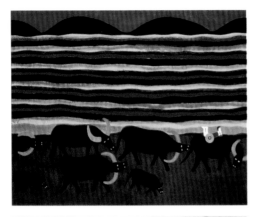

Grazing Cattle 65 × 55 cm Song Jinqi from Jinshan

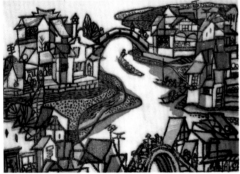

A Corner of a Riverside Village 80 × 80 cm Zhou Hongsheng from Songjiang

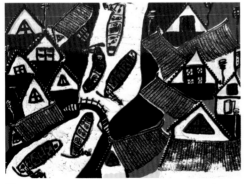

Spring in a Riverside Village 60 × 40 cm Gao Lianhuan from Songjiang

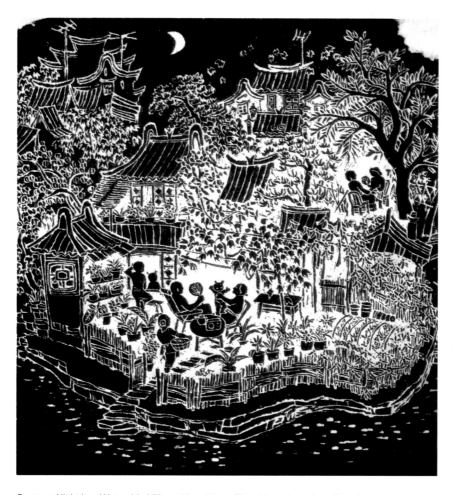

Summer Night in a Waterside Village 90 × 90 cm Zhou Hongsheng from Songjiang

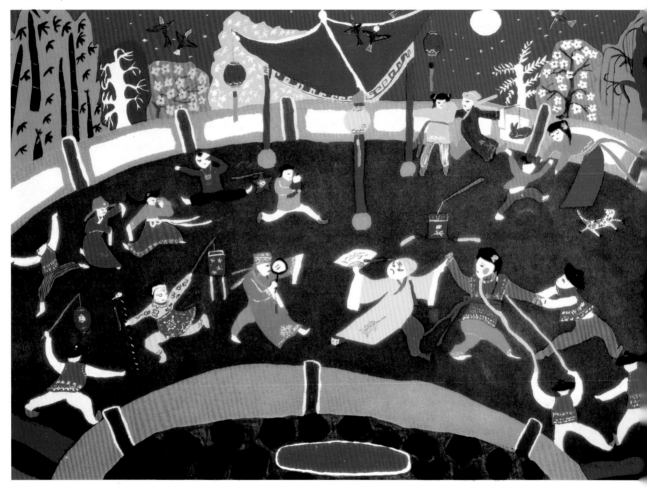

Tiger Wang Arbitrarily Marries a Girl
70 × 54 cm Zhou Jinming from Cixi

Legend has it that four hundred years ago Tiger Wang, the pampered son of a wealthy landlord, kidnapped Zhou Wenbin when the scholar was watching a lantern show disguised in female attire. He had not found a bride for himself, but a bridegroom for his sister instead. Picture shows the comic kidnap scene.

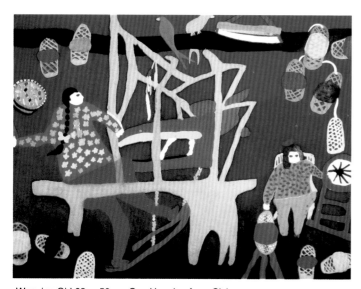

Weaving Girl 63 × 50 cm Cen Hongjun from Cixi

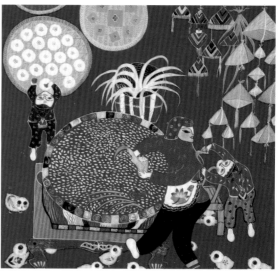

The Dragon Boat Festival 54 × 53 cm Wang Meizhen (female) from Fenghua

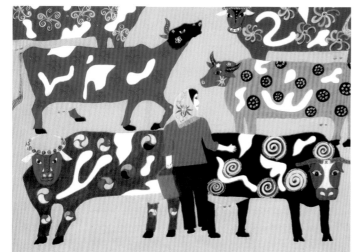

Cattle Farm 52 × 40 cm Fang Chunping (female) from Fenghua

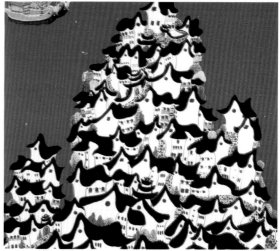

Village by the Sea 65 × 58 cm Hu Yongfa from Fenghua

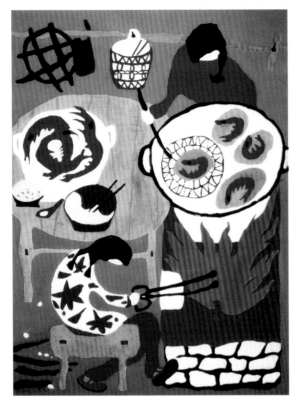

Frying Dough Cakes 64 × 50 cm Jiang Shenghui from Putuo

Sea Breeze 58 × 56 cm Yao Hongxia (female) from Dinghai ▷

Chanting Folktales to the Accompaniment of Percussion Instruments 61 × 51 cm Chen Zhen from Yiwu

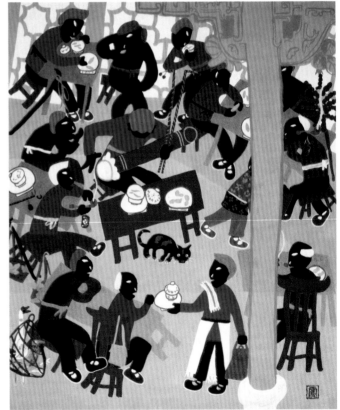

Netting Prawns 58 × 57 cm Yue Xiuzeng from Daishan

A Rush Repair 68 × 68 cm Cai Chengshi from Daishan

Song of Spring 78 × 56 cm Fang Baokui from Jiaxing

New Houses on a Mountain 52 × 41 cm Lu Dinan from Yuyao

Childhood 78 × 55 cm Zhang Guoliang from Liuhe

A Two-Storey Building in a Village 56 × 53 cm Sun Xiutao from Liuhe

Raising Clams in a Pond 103 × 76 cm Wu Shimin from Huanggang

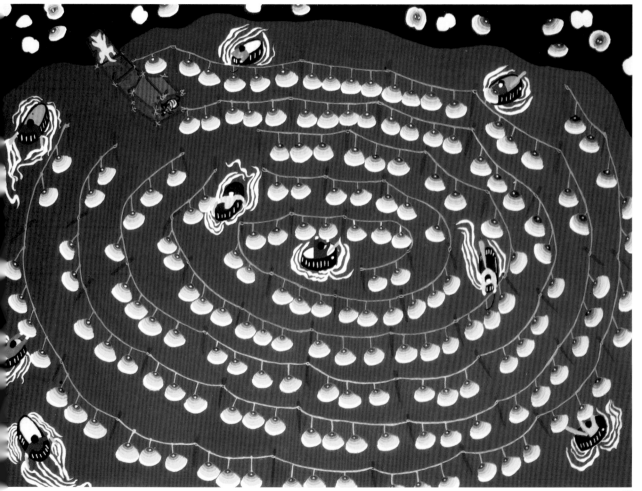

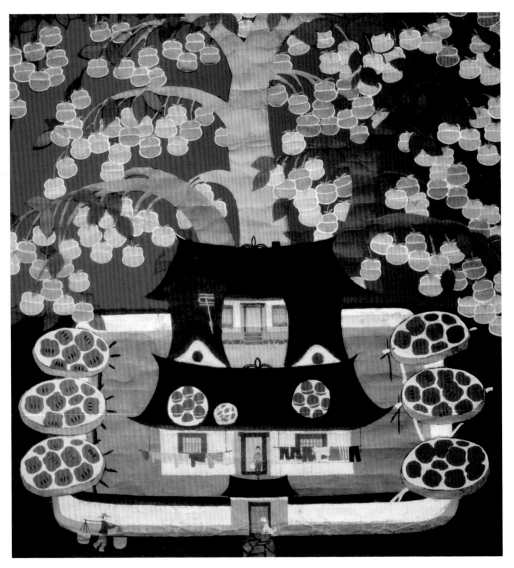

Sunning Persimmons 85 × 85 cm Hua Yihe from Huanggang

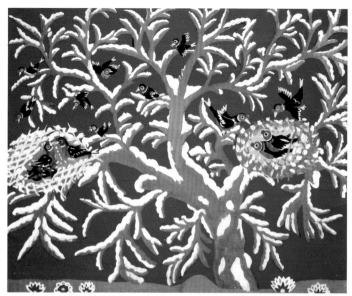

Bird Nests 85 × 70 cm
Wu Chun'e (female) from Huanggang

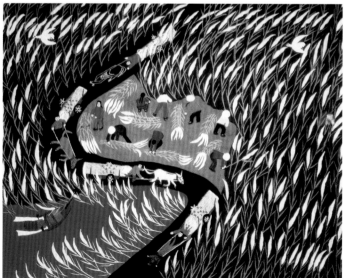

Harvesting Reed 90 × 70 cm
Wu Shimin from Huanggang

Mending Pots and Pans 79 × 54 cm Gong Guoli from Longhui

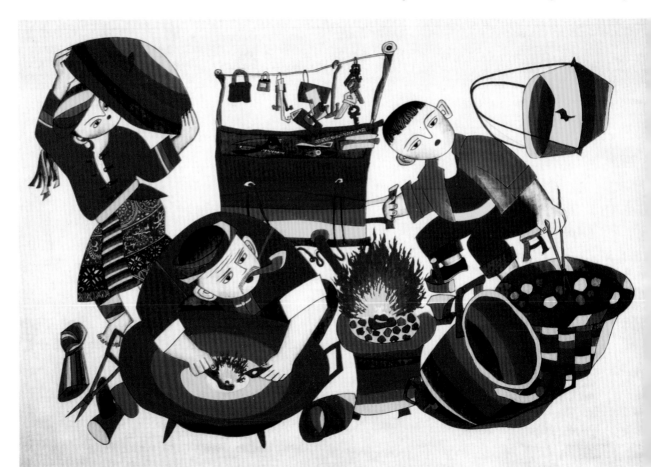

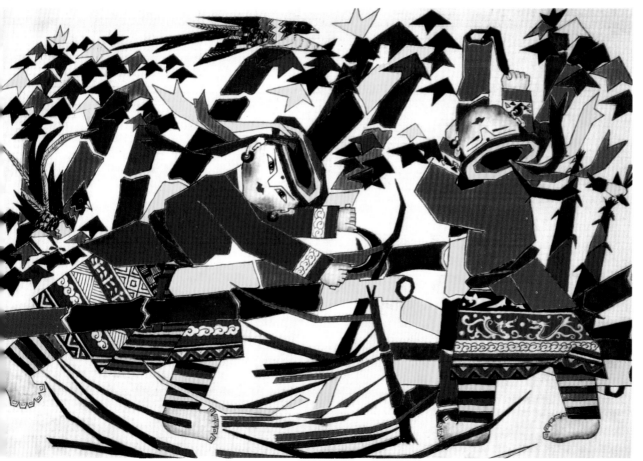

Mayang Miao Autonomous Region is well known for its festive lanterns. Non-governmental lantern associations organize lantern shows during festivals and holidays when girls dressed up as the Lantern Deity and boys made up as Ringwormed Beggar dance to

Cheering 63 × 55 cm Long Lingli (female) from Mayang

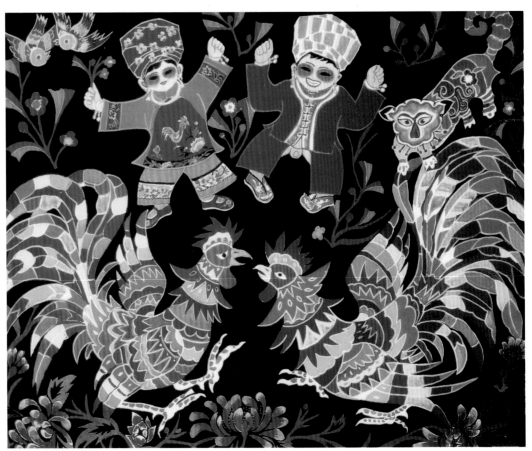

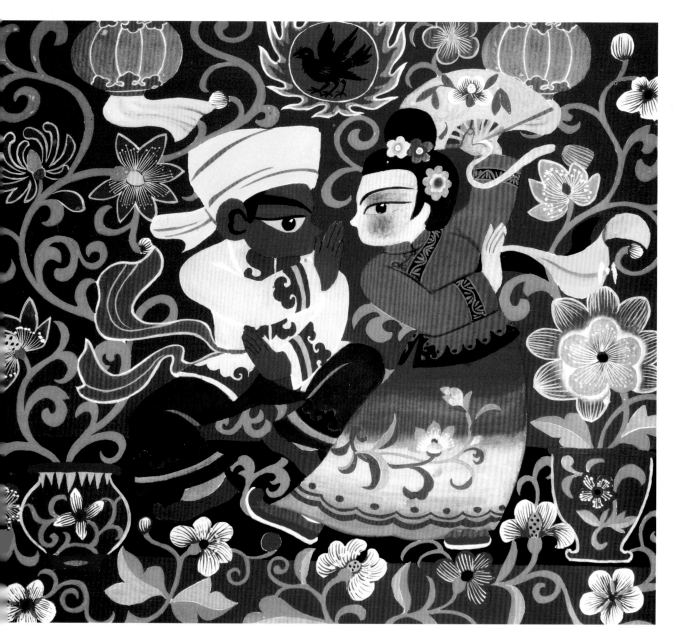

Rice-Noodle Stall 64 × 49 cm Wang Hanchi from Longmen

Grinding Millet 60 × 45 cm Luo Xiaoping from Longmen

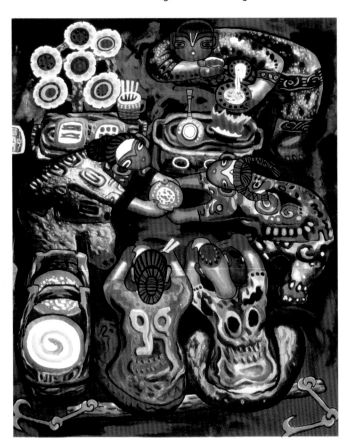

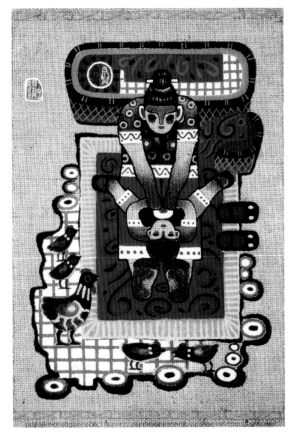

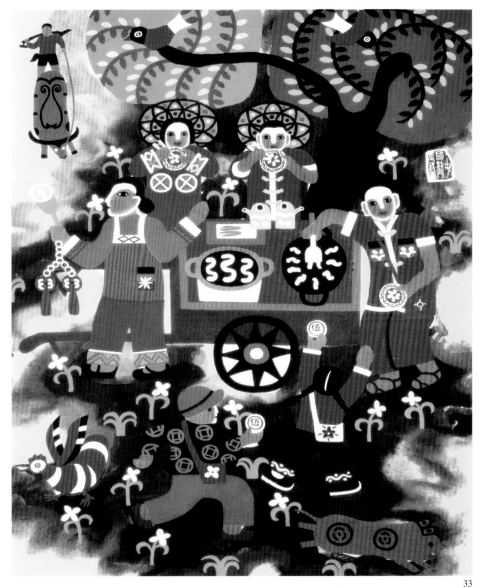

Gruel for Breakfast 50 × 40 cm
Huang Weiping from Longmen

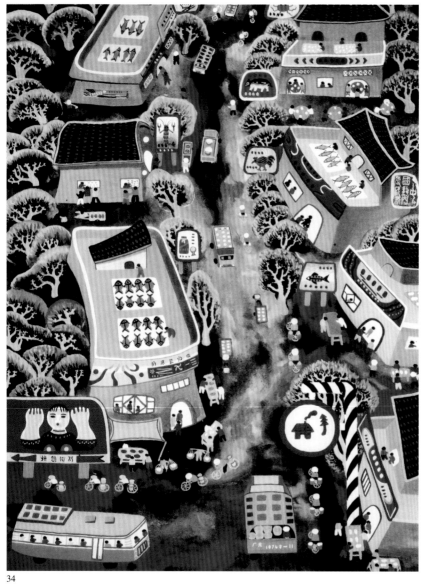

A Small Town 60 × 43 cm
Deng Paixuan and Liu Shuqi from Longmen

Fire-Dog Dance 53 × 47 cm
Zeng Baotian from Longmen

On the fifteenth of the eighth lunar month, the Yaos living in Lantian Village, Longmen County, Guangdong dance with torches in hand around imitation dogs in commemoration of their ancestors.

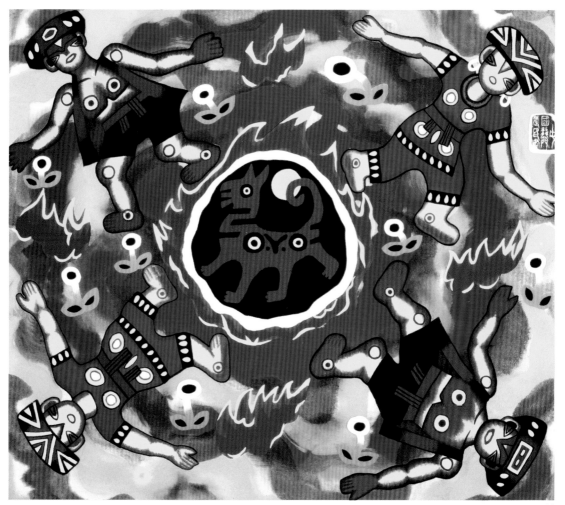

Making Perfection More Perfect 70 × 48 cm
Liang Jincheng from Tongan

Spring 68 × 47 cm Yan Mingsuan from Tongan

Tea-Picking Dance 70 × 48 cm Huang Ruifu from Tongan

Grinding Oil-Tea 100 × 80 cm
Wang Moxiang from Zhangping

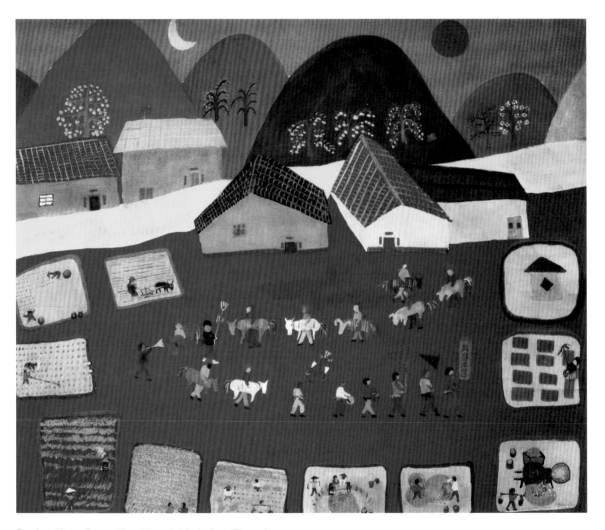

Bamboo-Horse Dance 90 × 70 cm Lai Dake from Zhangping

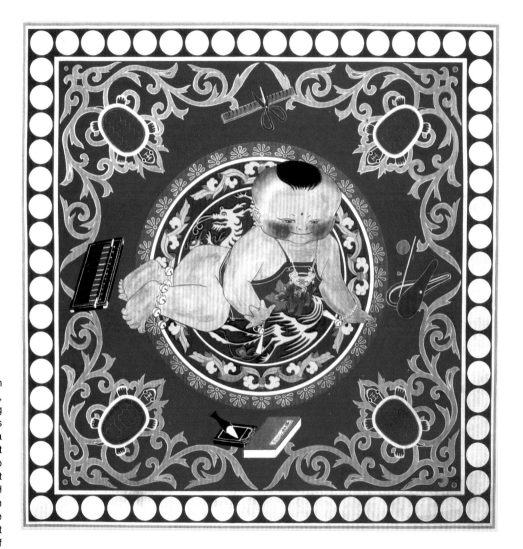

The custom in southern Fujian is to lay out brushes, inkstone, abacus, weighing scale, scissors, carpenter's ruler and other things for a baby to grab on his first birthday. If he picks up brushes and inkstone, it means he will be learned and become an official in the future. If he grabs the abacus and scale, he might become a merchant. And if he takes the scissors or ruler he is most likely to become a handicraftsman.

What's Baby's Favourite? 60 × 60 cm Wang Guangmeng from Jinjiang

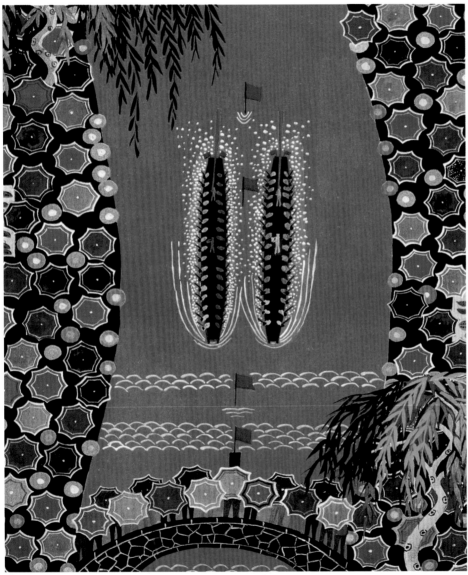

Dragon-Boat Race 108 × 78 cm
Zheng Youhe from Longhai

Feeding the Fish 90 × 60 cm Huang Qingchui
from Longhai

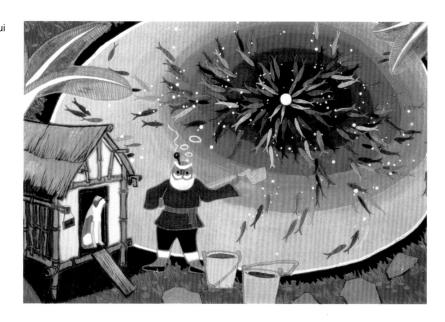

Digging for Taros 90 × 60 cm Li Meilian (female) from Longhai

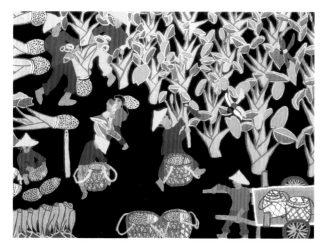

Sunning Lichi Nuts 90 × 70 cm Sun Jianzhong from Longhai

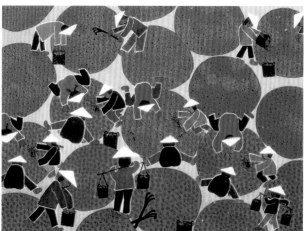

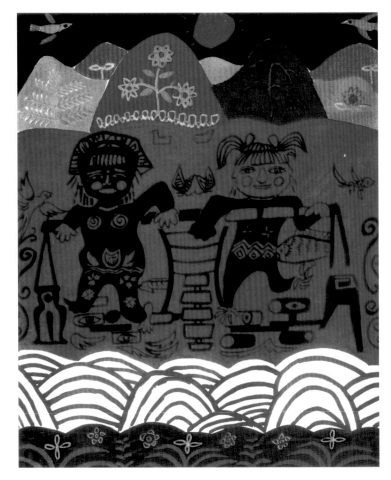

Waterwheel 70 × 50 cm Lin Yutao from Putian

Treading Fire on the Lantern Festival 90 × 70 cm Lin Yuanhong from Putian

A Monkey Show 70 × 61 cm Long Chengqian from Luxi District, Pingxiang City

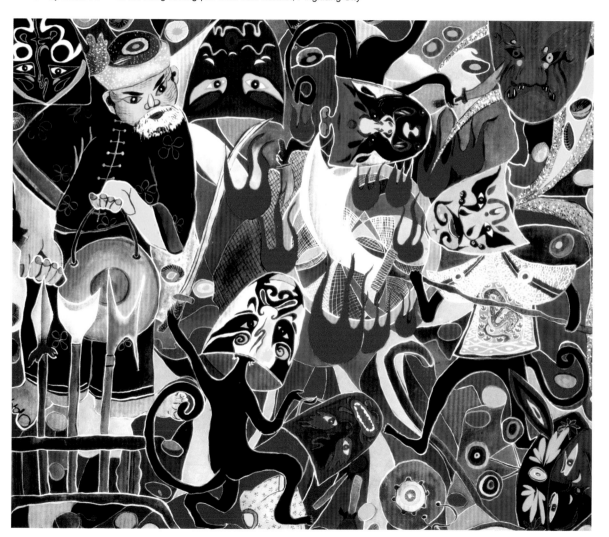

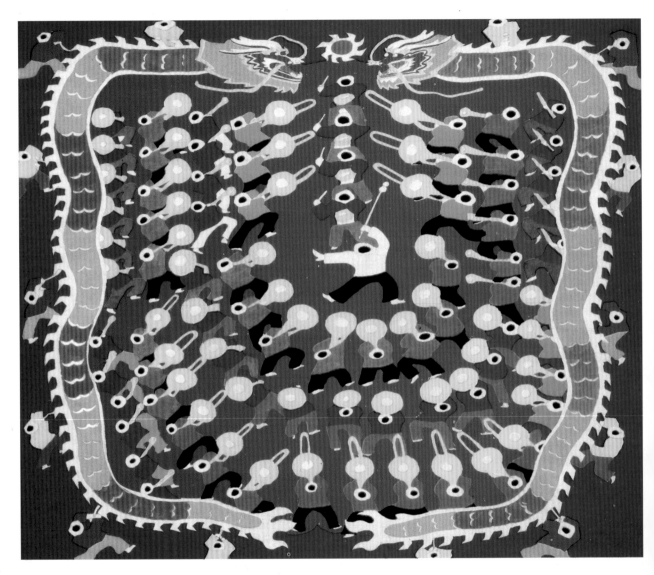

A Bumper Harvest 55 × 47 cm Ma Yemin from Xiangdong District, Pingxiang City

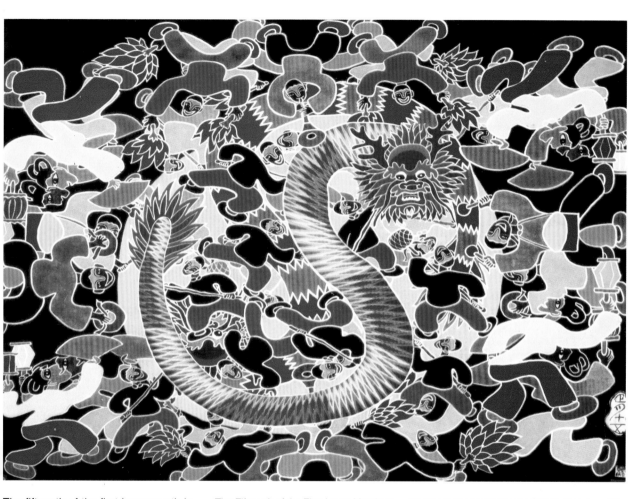

The fifteenth of the first lunar month is China's traditional Lantern Festival when peasants dance in the moonlight to the accompaniment of gongs and drums, holding in their hands torches, dragon lanterns, tea lanterns, lion lanterns and carp lanterns to herald a new spring.

The Fifteenth of the First Lunar Month 64 × 54 cm Liu Zhibing from Luxi Distrct, Pingxiang City

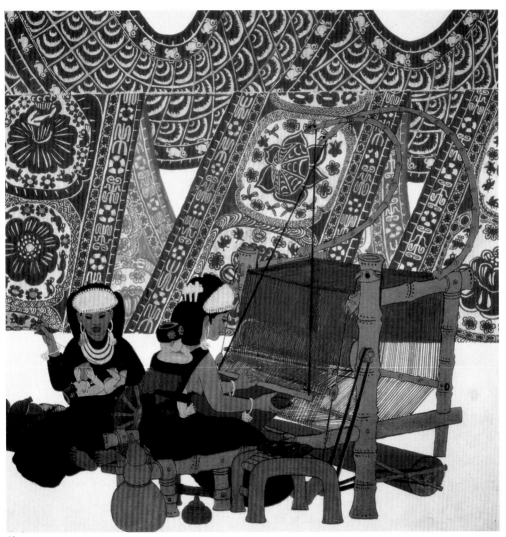

A Yao Family Weaving
60 × 60 cm Meng Guiming
from Du'an

Cock Fight 108 × 78 cm Huang Kuijun from Rizhao

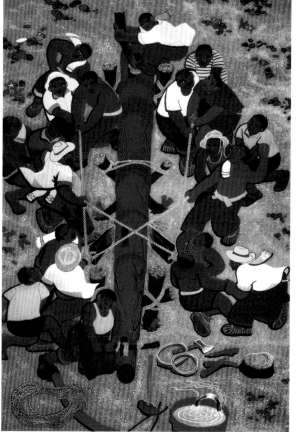

Forging Hoop Iron 80 × 52 cm
Fu Chengfeng from Rizhao

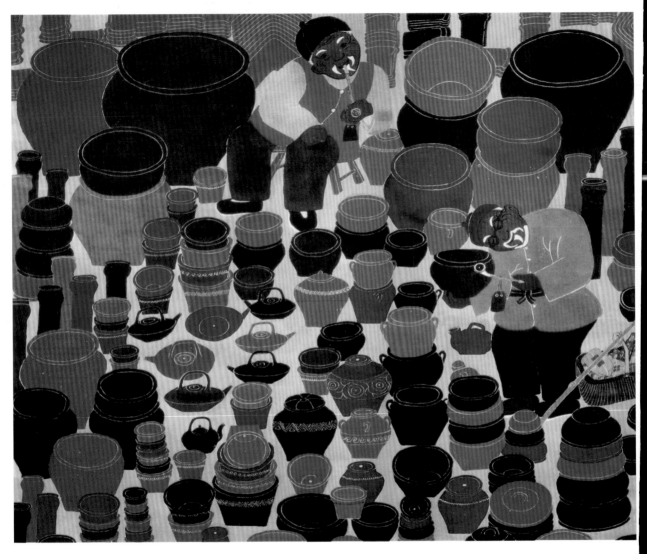

Pottery for Sale 70 × 70 cm Zhang Yuqin (female) from Rizhao

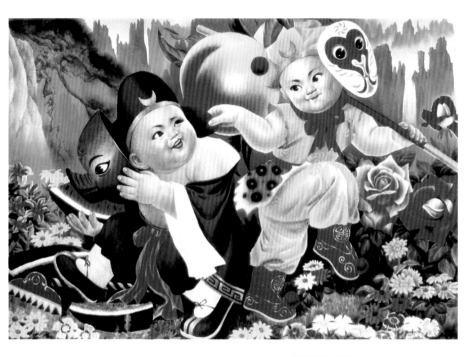

Pigsy Eating Melon 108 × 78 cm
Chen Ming from Jiaoman

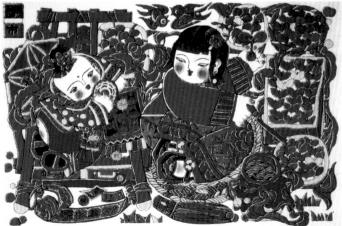

A Market in Spring 107 × 73 cm
Ding Ximing from Zhucheng

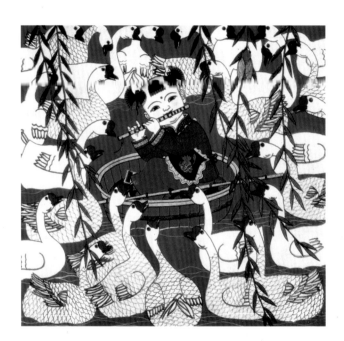

A Village Tune 47 × 45 cm Lu Li (female) from Linqu

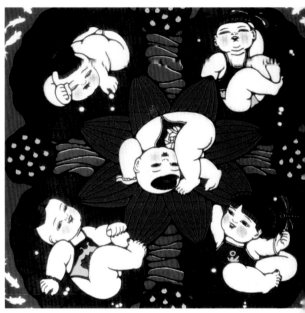

Five Sons Playing in a Pond 51 × 48 cm
Qiu Huaixia (female) from Linqu

In Wuyag, Henan, legend has it that the sixth day of the sixth lunar month is the birthday of the ants when every household bakes sesame buns to celebrate.

The Sixth of the Sixth Lunar Month 78 × 54 cm Wang Tingzhi from Wuyang

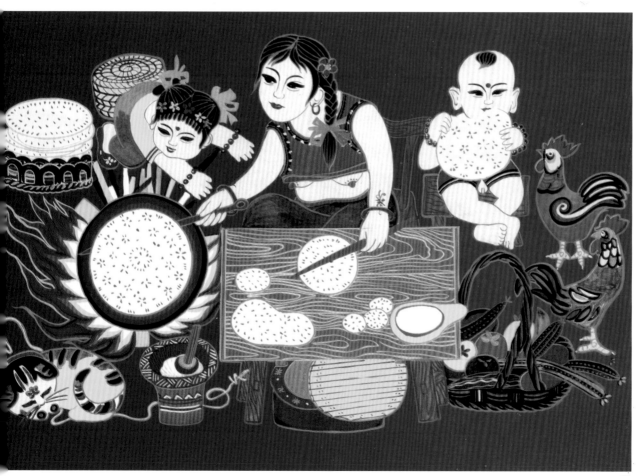

In summer, men and women in Wuyang of Henan used to bathe in the moonlight at different river bends.

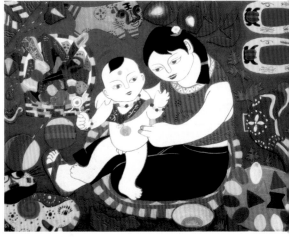

The Dragon Boat Festival 67 × 51 c
Gu Jian from Wuyang

At the River Bend 77 × 54 cm
Wu Tianju and Huang Aijun (female) from Wuyang

Legend has it that Lu Ban the master craftsman prided himself on his superb workmanship in building the Zhaozhou Bridge. When Deity Zhang Guolao learned about it, he sat facing backwards astride a donkey with the sun, the moon and stars in his hands. He also made King Chai push a barrow loaded with three huge mountains onto the bridge which shook under the weight. Lu Ban quickly steadied it with his hands. Actually, Zhaozhou Bridge, situated in central Hebei, was built by Li Chun at the end of the sixth century.

HEBEI PROVINCE China

Legend of the Zhaozhou Bridge 79 × 55 cm
Hu Shuangyue from Xinji

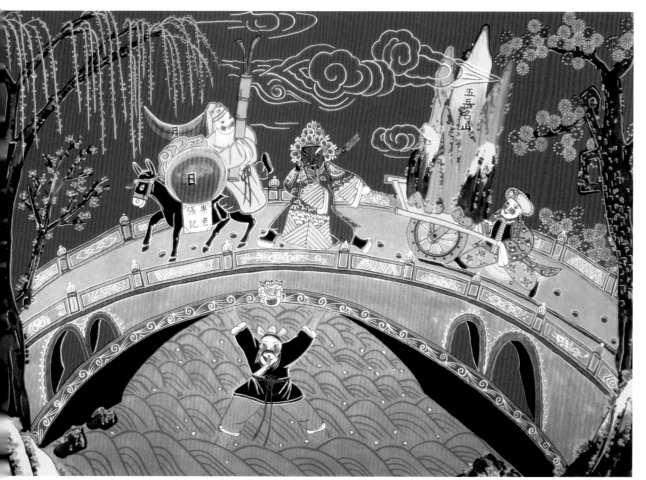

Fish Pond 78 × 55 cm Chen Jiaqi from Beijiao District

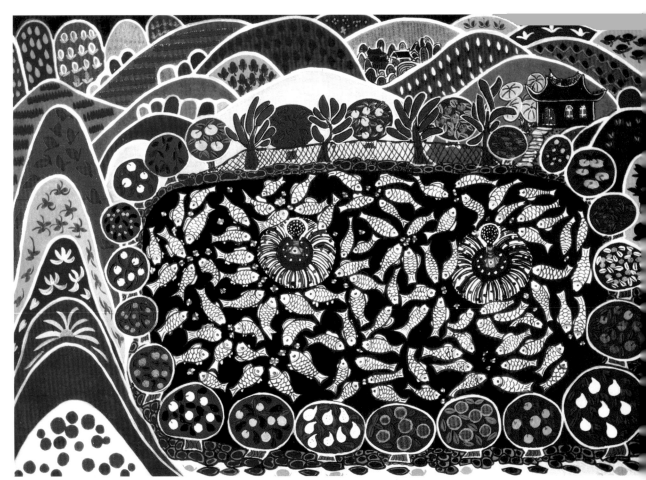

A Market in Spring 94 × 62 cm
Feng Aidong from Beijiao District

The legendary auspicious animal unicorn is said to bring sons to kindhearted couples.

The Unicorn Brings a Son 73 × 53 cm
Qin Chengyu from Beijjao District

Wedding 59 × 42 cm Wang Yongchang from Daixian

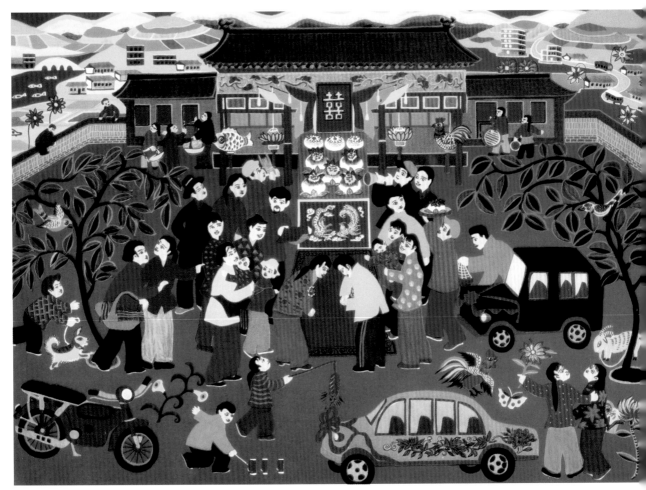

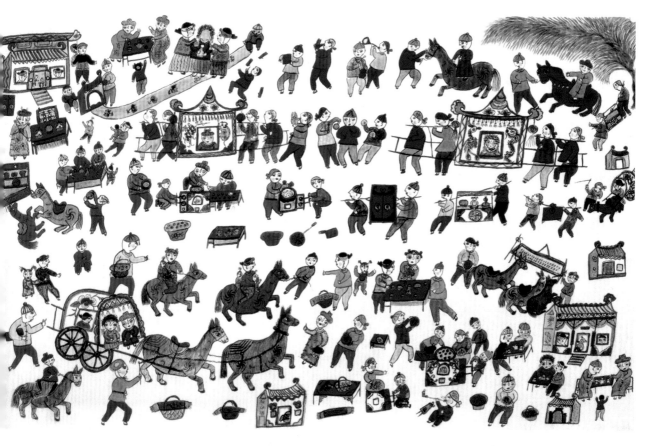

Wedding Procession 88 × 55 cm Tian Sannu (female) from Daixian

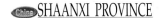

Oxen Heads 77 × 60 cm Xue Yuqin (female) from Ansai

Villagers in Ansai, northern Shaanxi, like to paint on stoves, brick beds and make papercuts. Modern folk painting in Ansai has developed on the basis of this ancient tradition. Simple and exaggerative, the paintings are highly decorative.

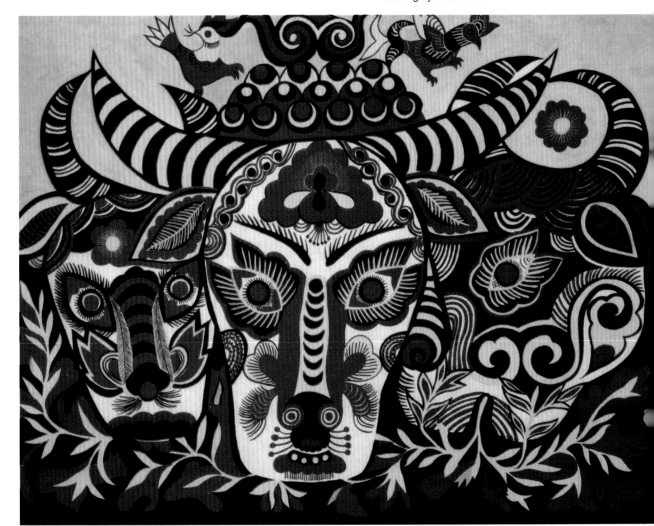

Smoking Monkey 79 × 59 cm Zhang Zhilan (female) from Ansai

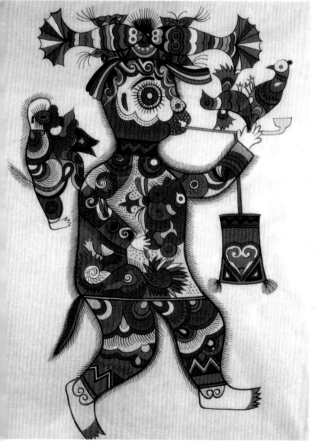

Taming Tiger 88 × 57 cm Gao Jinai (female) from Ansai

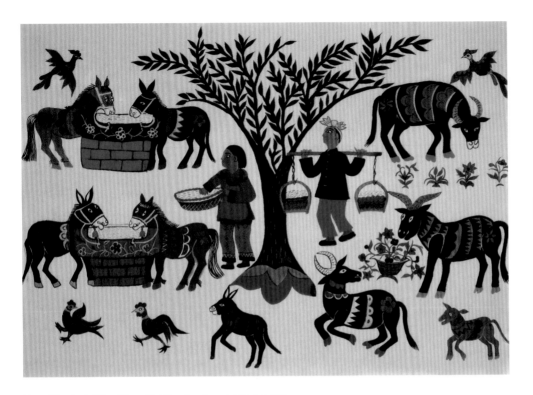

Many Livestock 72 × 50 cm Bai Fenglan (female) from Ansai

In ancient times, twelve kinds of animals represent the twelve Earthly Branches such as rat representing *zi*, ox representing *chou*, tiger representing *yin*, rabbit representing *mao*, dragon representing *chen*, snake representing *si*, horse representing *wu*, sheep representing *wei*, monkey representing *shen*, rooster representing *you*, dog representing *xu* and boar representing *hai*. Later, people consider themselves to be represented by the animal of the year they are born in.

The Twelve Kinds of Animals 72 × 49 cm Cao Dianxiang (female) from Ansai

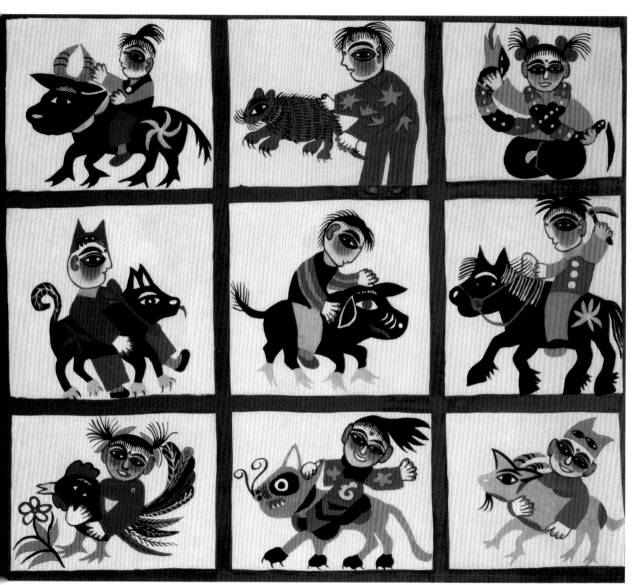

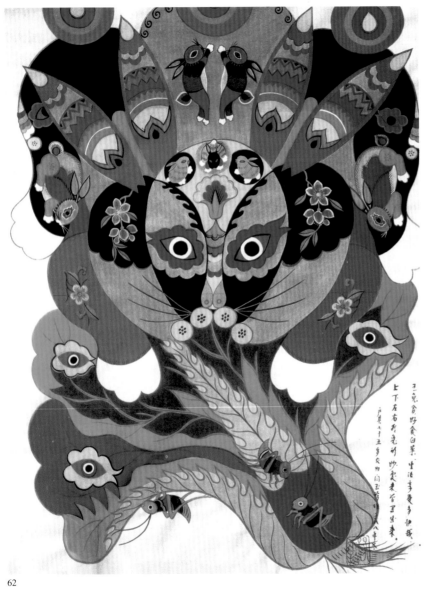

玉兔食好食白菜，生活事爱多快乐，
上下左右新兔前炒炒炒来看看来。
一序兔十五多尺四间玉前□□□□中

Rabbits 108 × 78 cm
Yan Yuzhen (female) from Huxian

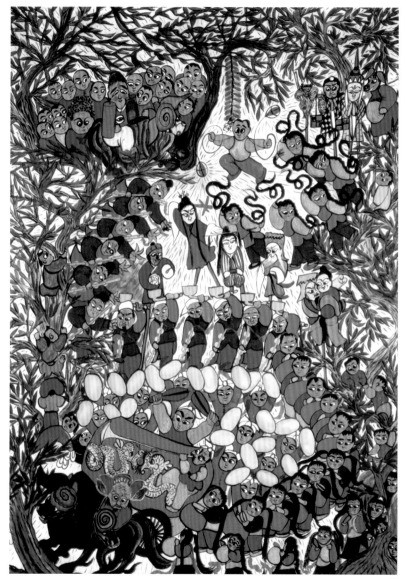

Celebrating a Bumper Harvest 122 × 88 cm
Wang Jinglong from Huxian

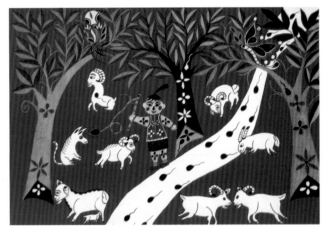

Shepherd Boy 57 × 38 cm
Ma Xiuying (female) from Luochuan

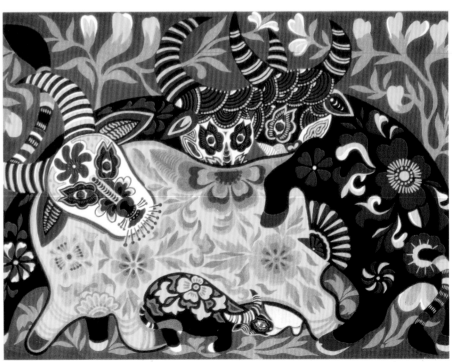

Rivals in Love 108 × 78 cm
Luo Zhijian from Huxian

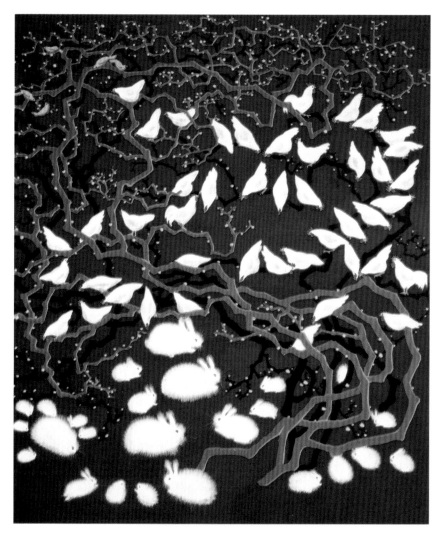

Chickens and Rabbits 72 × 60 cm Wei Pengpeng from Huxian

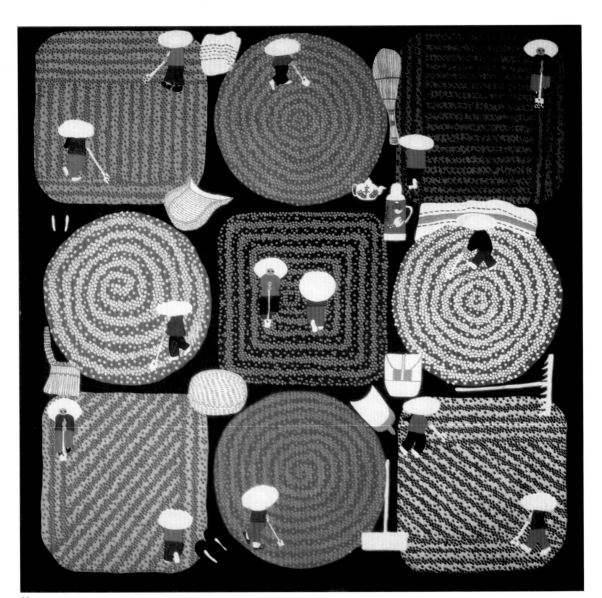

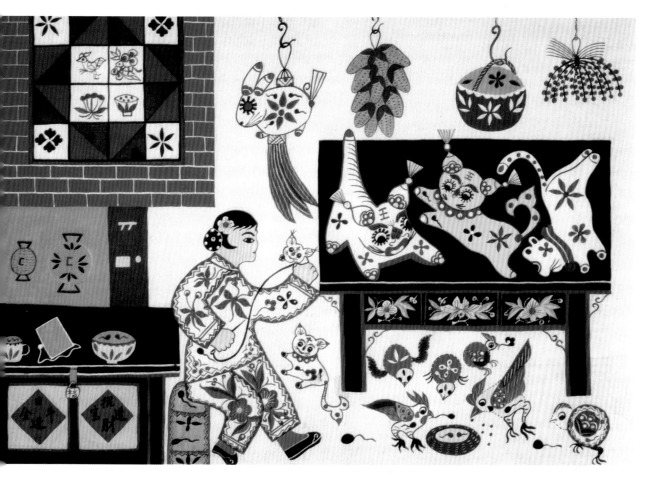

Skilful Wife 58 × 39 cm Ma Xiuying (female) from Luochuan

Sunning Grain 88 × 88 cm
He Yaling (female) from Huxian

In Luochuan, northern Shaanxi, during the Dragon Boat Festival, women used to make bird-, animal- or fruit-shaped fragrant bags stuffed with sweetgrass and realgar and hang them around the neck as a talismen as well as a celebration of the festival.

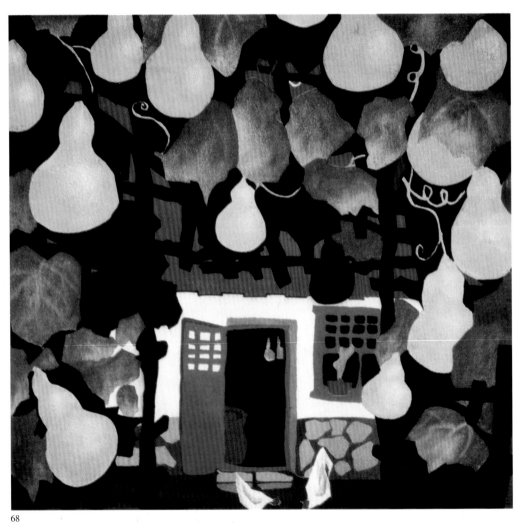

Gourds in Autumn
57 × 55 cm
Zhang Fengxiang
(female) from Acheng

Teasing the New Couple in Their Bridal Room 88 × 79 cm Zhang Denian from Jilin City

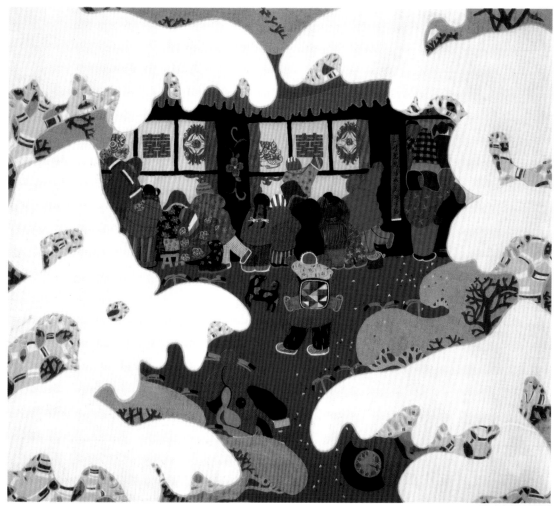

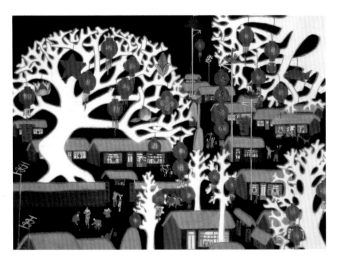

Spring in a Village 87 × 66 cm Liu Dianlin from Jilin City

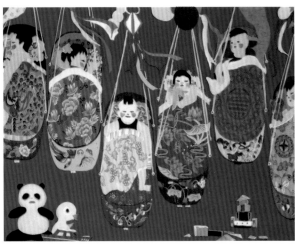

Lullaby 96 × 62 cm Jin Hua (female) from Dongfeng

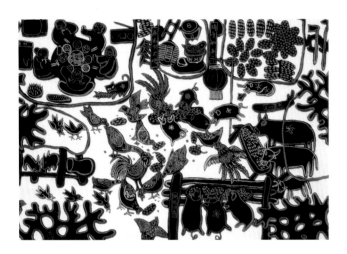

Ready for a New-Year Festival 88 × 60 cm
Zhang Denian from Jilin City

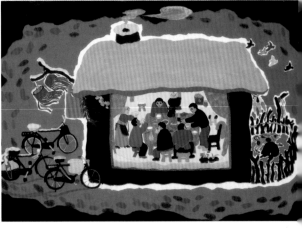

Village Wineshop 74 × 51 cm
Zheng Guixiang (female) from Dongfeng

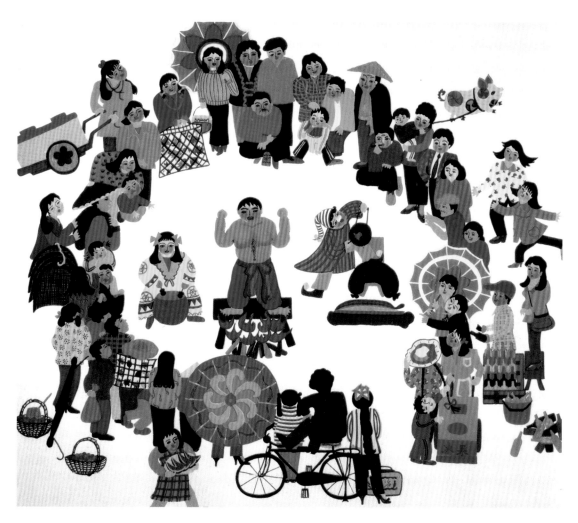

An Acrobatic Show 69 × 63 cm Li Guoli (female) from Dongfeng

Impressions of Childhood 79 × 61 cm Zhang Yingzhou from Xinmin

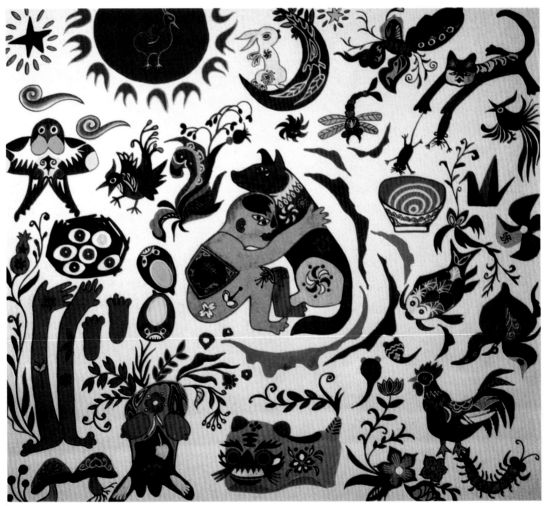

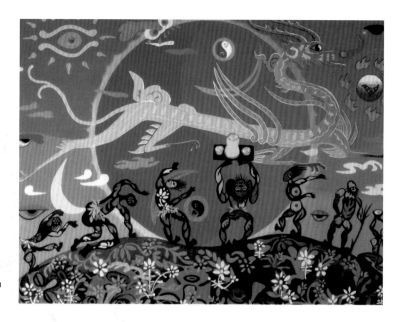

Our Ancestors 69 × 54 cm
Wu Shuchun from Xinmin

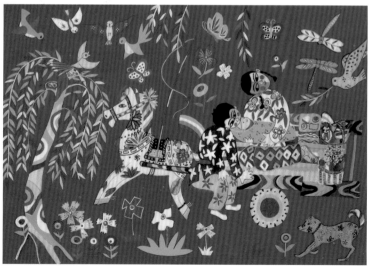

A Married Daughter Visiting Her Mother
81 × 59 cm Liu Hongxia from Xinmin

Spring 55 × 55 cm
Zhao Chunhui from Xiuyan

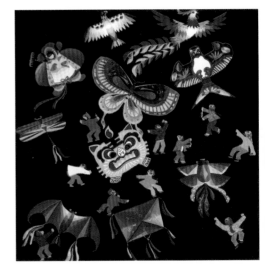

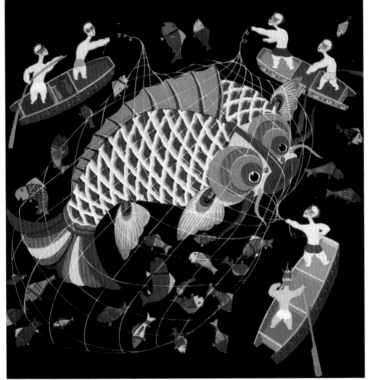

A Big Catch 55 × 55 cm Li Qiang from Xiuyan

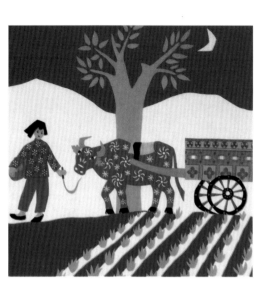

Peasant Woman 55 × 55 cm
Wang Junjiang from Xiuyan

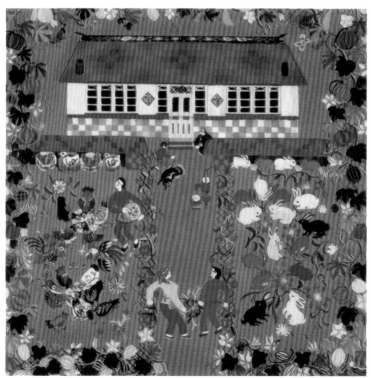

Spring in Courtyard 55 × 55 cm
Zhang Xiangwen from Xiuyan

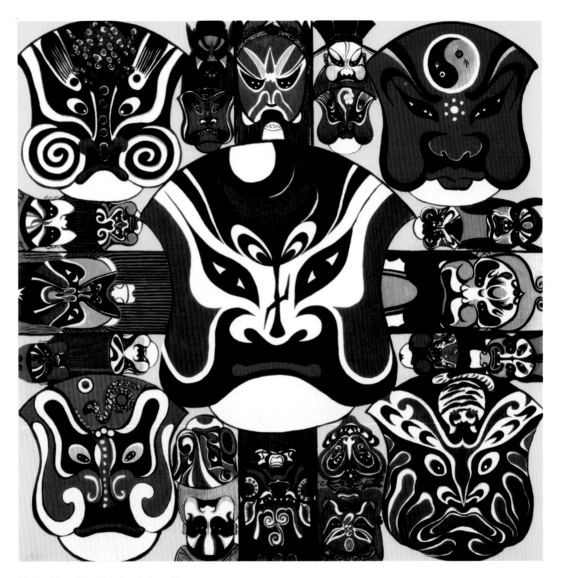

Masks 55 × 55 cm Liu Renjie from Xiuyan

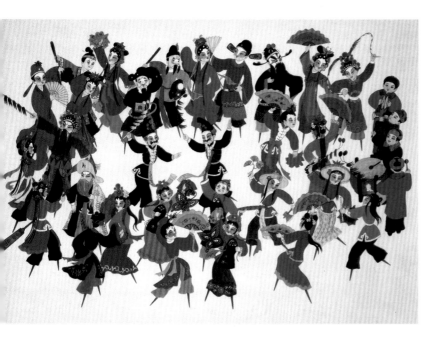

Happiness in Spring 98 × 66 cm
Shi Xiumei (female) from Sujiatun, Shenyang

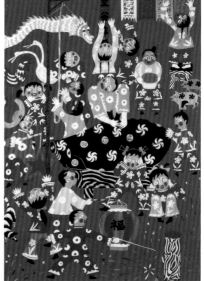

New Year 73 × 52 cm
Li Xinghua from Zhangwu

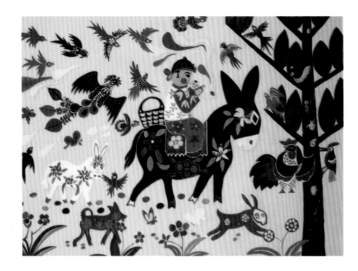

Going to a Fair 55 × 40 cm
Wang Dezhi from Liaozhong

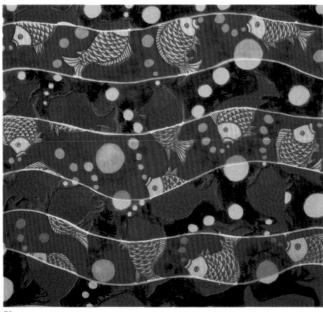

Teeming Goldfish 40 × 39 cm
Hong Bing from Zhuanghe

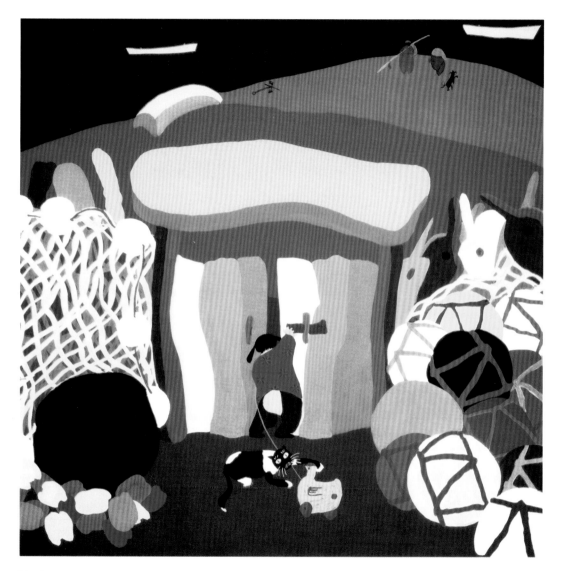

Morning 66 × 65 cm Bi Wufu from Jinzhou, Dalian

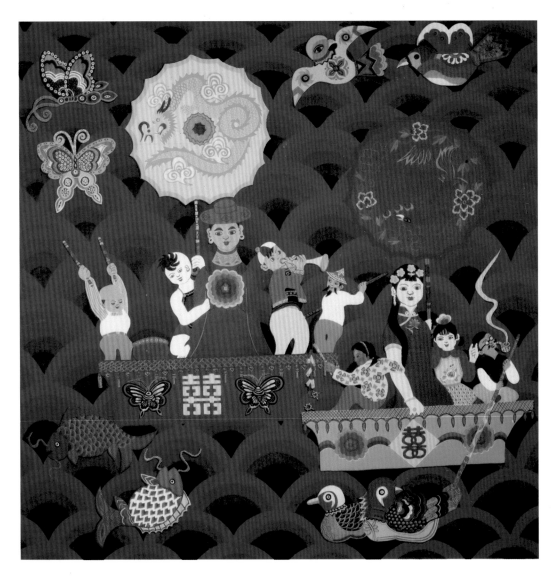

A Wedding Ceremony on the Sea 77 × 76 cm Song Shaode from Donggou

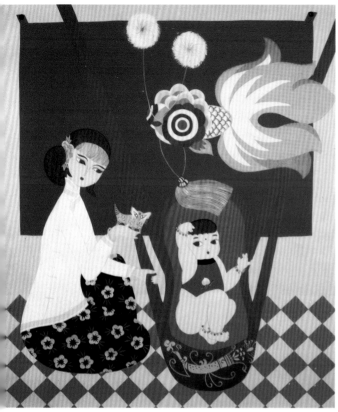

Mother 79 × 71 cm Qin Xiujuan (female) from Donggou

A Married Daughter Paying a Visit to Her Mother
70 × 55 cm He Fengli (female) from Donggou

Tiger Girl 42 × 38 cm Ren Fengshan from Benxi

Childhood 44 × 35 cm Liu Yonglu from Qijiang

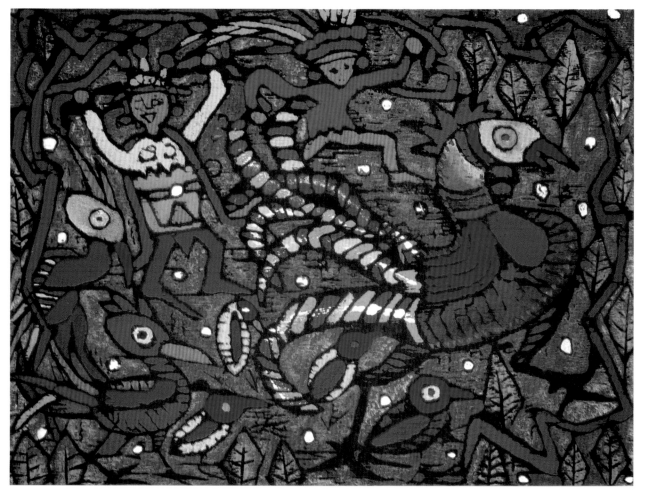

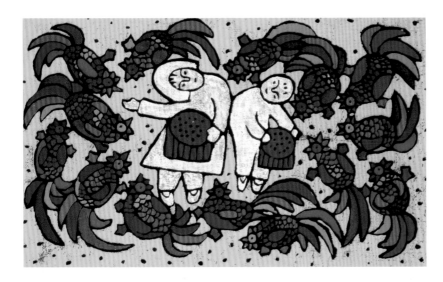

Happy Country Life 60 × 37 cm
Gui Huanyong from Qijiang

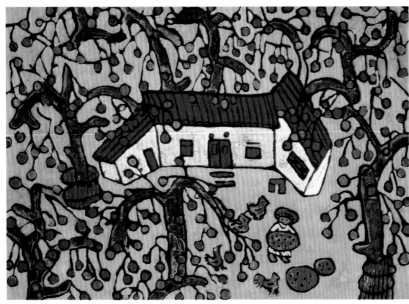

Golden Autumn 55 × 40 cm
Xiong Qiu from Qijiang

The fifteenth of the ninth lunar month is the Close-door *(jinao)* Festival of the Dai ethnic group while the fifteenth of the twelfth lunar month is the Open-door *(chuao)* Festival. The period between the two festivals is a long fast when young people must not court or marry. The night of *chuao* has been long awaited by young men and girls.

Evening of the Open-door Festival
79 × 52 cm Xiu Ying (Dai) from Ruili

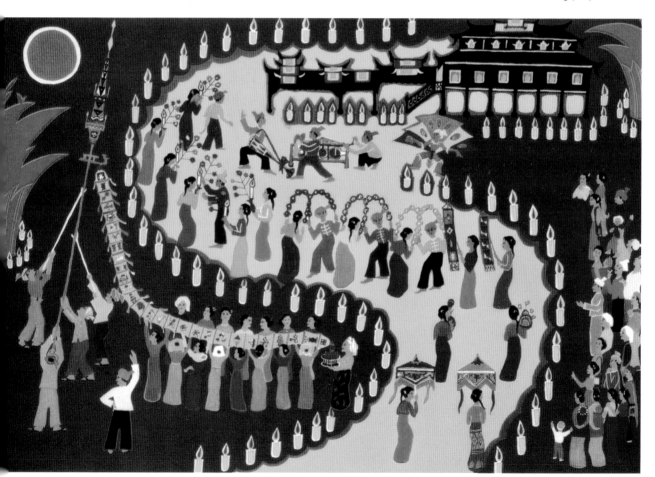

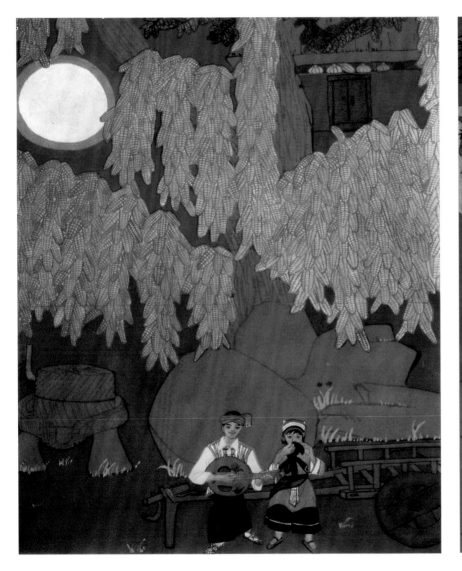

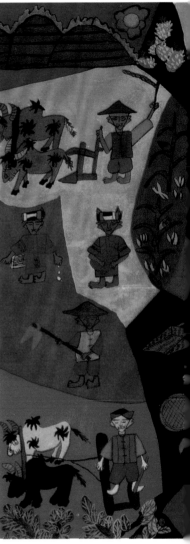

A Night in Golden Autumn 90 × 70 cm Bi Wenming (Yi) from Lunan

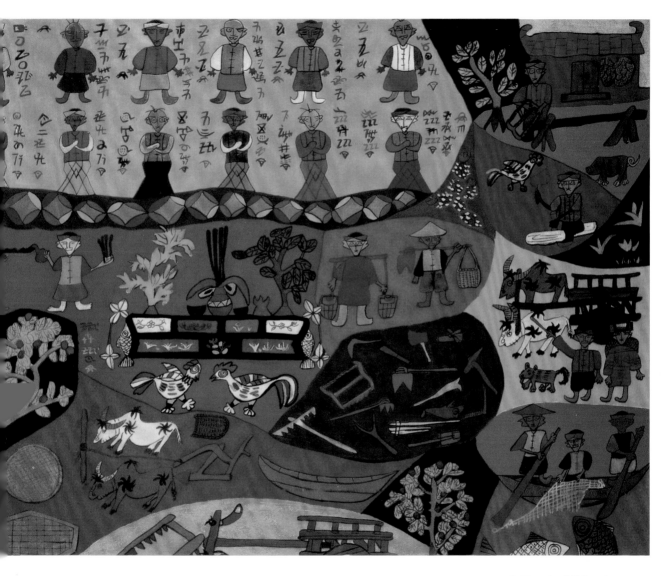

The Sani People 106 × 76 cm Bi Wenming (Yi) from Lunan

"Bag-throwing" is a courting activity of the Dai young people before marriage. The girl throws a bag to the young man she fancies to convey her feelings for him.

Throwing Bags During Courting 73 × 55 cm Sinan (Dai) from Ruili

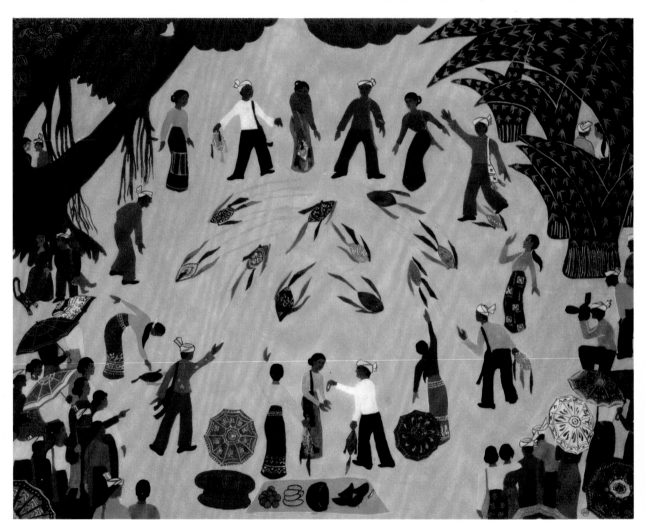

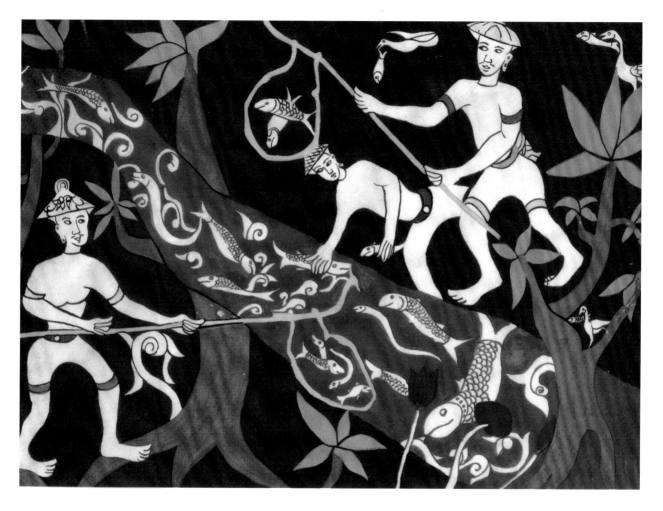

Fish in a Brook 55 × 40 cm Neisai (Dai) from Ruili

A Tobacco Harvest 70 × 50 cm Jiang Qingyun from Lunan

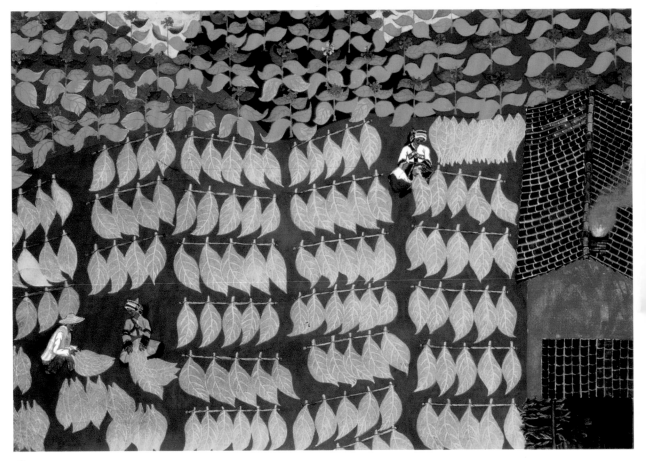

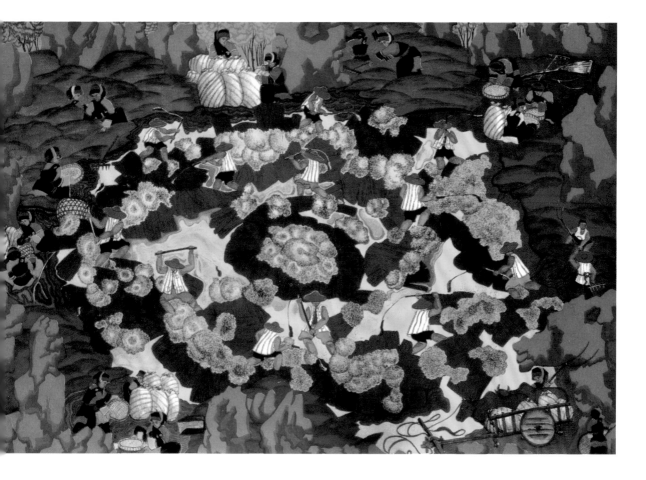

Harvesting Buckwheat 108 × 78 cm Bi Wengui (Yi) from Lunan

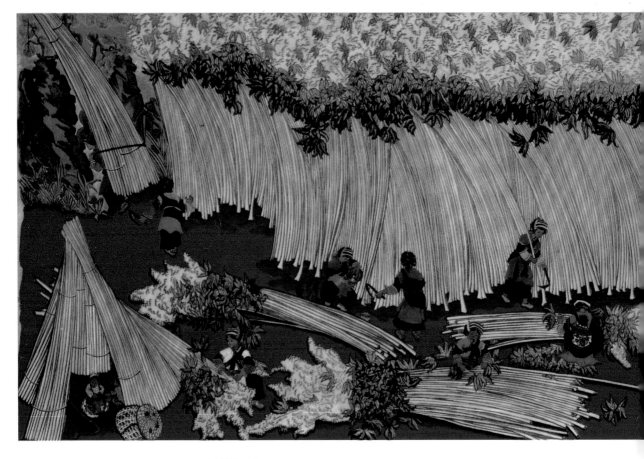

Harvesting Hemp 90 × 70 cm Bi Wengui (Yi) from Lunan

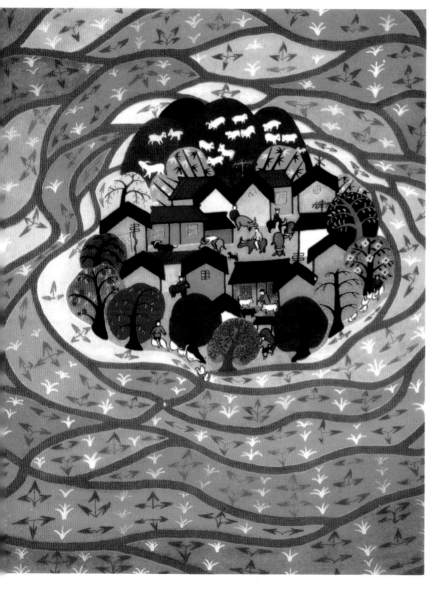

Mountain Village 64 × 52 cm
Yu Xinghua (Mongolian) from Dafang

Shepherding 74 × 57 cm Cen
Tianmei (female, Bouyei) from Shuicheng

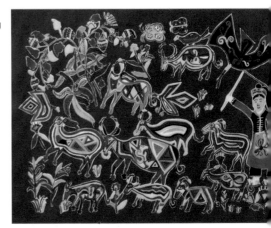

Honeysweet is a wild fruit in the
mountains of northwest Guizhou. It's
red and sweet and the picking season
comes after the Dragon Boat Festival.

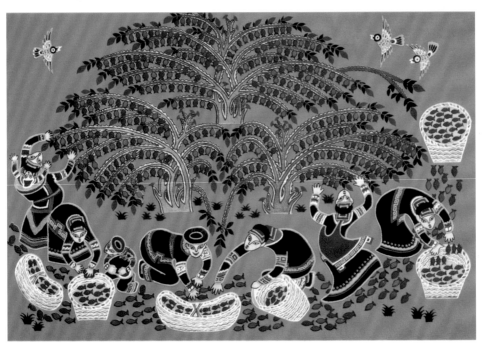

Honeysweets in the Mou
73 × 51 cm Wang Wenju
Dafang

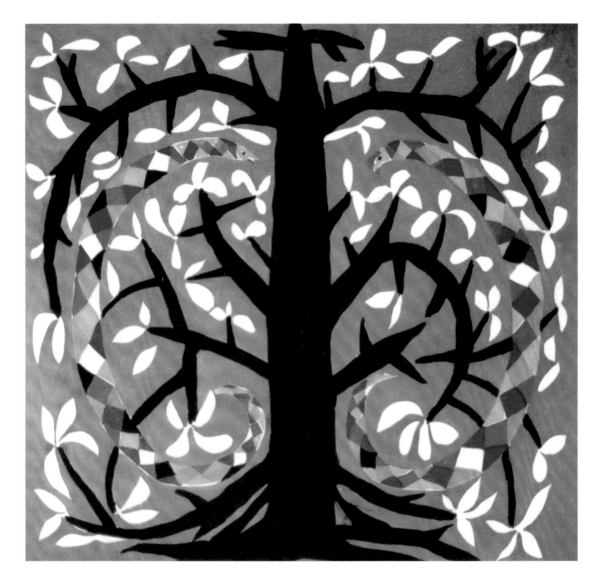

Forest 81 × 59 cm Cen Tianfen (female, Bouyei) from Shuicheng

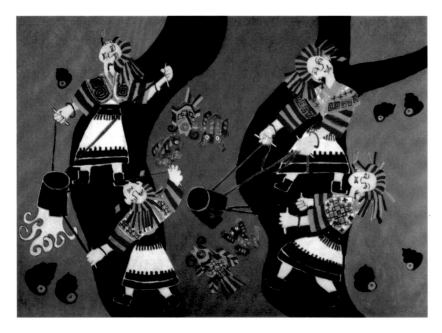

Irrigating the Fields 78 × 56 cm Xu Chenggui from Shuicheng

An Abundance of Chickens and Eggs
70 × 45 cm Tang Wenmin from Huangping

A Bridal House 78 × 54 cm
He Changyuan from Meitan

Fish Pond 64 × 48 cm Wang Zhiying
(female, Miao) from Majiang

The Dong people offer oil-tea to honorable guests and relatives and friends calling on festivals and happy occasions. On her wedding day, the bride prepares oil-tea for the guests while her friends sing.

Come and Have Tea in a Dong Household
49 × 47 cm Li Wanzeng (Dong) from Jianhe

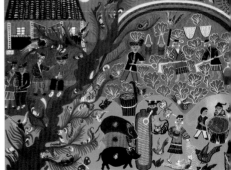

Rainbow over a Miao Village
79 × 54 cm Ou Dehua (Miao) from Jianhe

Going to a Village Fair 72 × 48 cm Avdu-samad from Markit

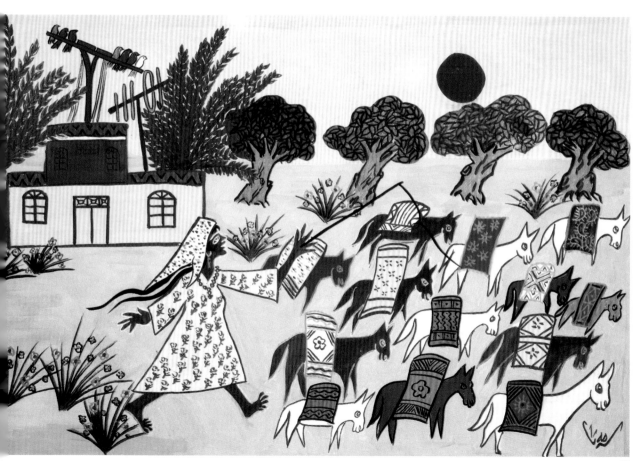

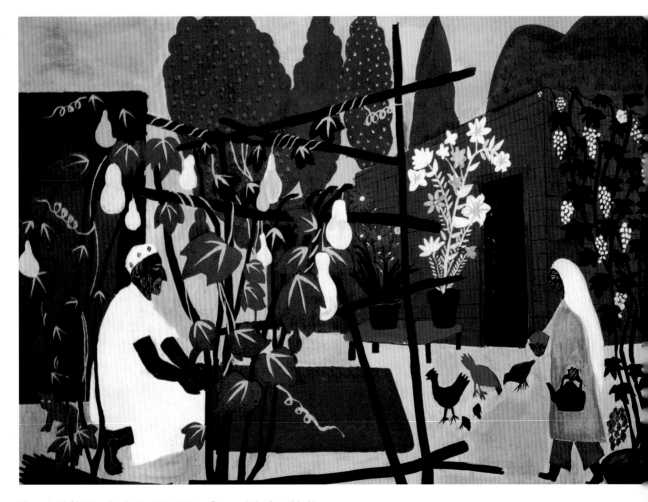

Household Sideline Production 97 × 70 cm Osman Abba from Markit

Uygur dancers humorously imitate, in their dancing, cocks and hens pecking for food, roosting, hatching, protecting young chicks and fighting the eagle together.

Chicken Dance 72 × 49 cm Abdu-rahiim from Hami

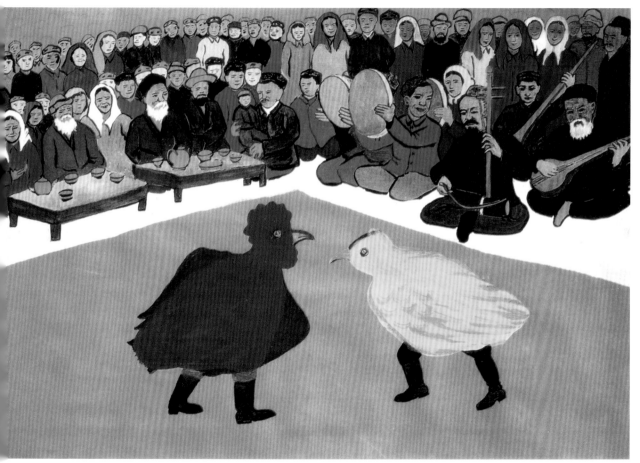

This is a Uygur love story. Deeply in love Gharib and Senam fought against evil lords and aristocrats for a happy life together. Picture depicts a secret meeting of the two.

Gharib and Senam 73 × 49 cm Zohragul (female) from Hami

Spring Sowing 105 × 75 cm
Aga Khan from Hami

Taking Off the Scarf in a Wedding
69 × 49 cm Chendashkhan
(female) from Hami

A Lion Dance on the Grasslands 108 × 78 cm Xu Quanxi from Huangzhong

Map of "Homes of Painting"

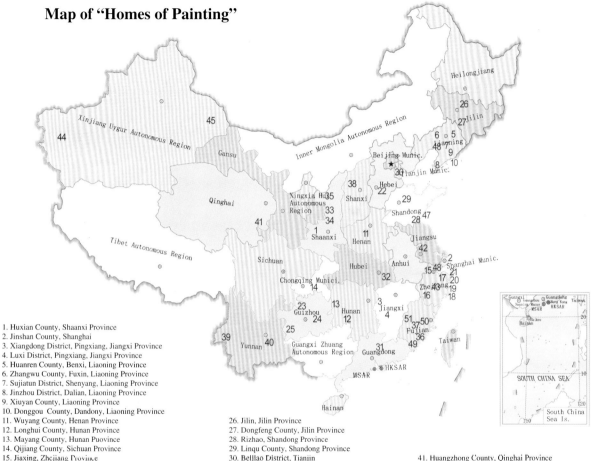

1. Huxian County, Shaanxi Province
2. Jinshan County, Shanghai
3. Xiangdong District, Pingxiang, Jiangxi Province
4. Luxi District, Pingxiang, Jiangxi Province
5. Huanren County, Benxi, Liaoning Province
6. Zhangwu County, Fuxin, Liaoning Province
7. Sujiatun District, Shenyang, Liaoning Province
8. Jinzhou District, Dalian, Liaoning Province
9. Xiuyan County, Liaoning Province
10. Donggou County, Dandony, Liaoning Province
11. Wuyang County, Henan Province
12. Longhui County, Hunan Provice
13. Mayang County, Hunan Puovince
14. Qijiang County, Sichuan Province
15. Jiaxing, Zhejiang Province
16. Yiwu County, Zhejiang Province
17. Cixi County, Zhejiang Province
18. Putuo District, Zhoushan, Zhejiang Province
19. Dinghai District, Zhoushan, Zhejiang Province
20. Daishan County, Zhoushan, Zhejiang Province
21. Shengsi County, Zhoushan, Zhejiang Province
22. Xinji, Hebei Province
23. Dafang County, Guizhou Province
24. Huangping County, Guizhou Province
25. Shuicheng, Guizhou Province

26. Jilin, Jilin Province
27. Dongfeng County, Jilin Province
28. Rizhao, Shandong Province
29. Linqu County, Shandong Province
30. Beljlao District, Tianjin
31. Longmen County, Guangdong Province
32. Huanggang County, Hubei Province
33. Luochuan County, Shaanxi Province
34. Yijun County, Shaanxi Province
35. Ansai County, Shaanxi Province
36. Jinjiang, Fujian Province
37. Tongan County, Fujian Province
38. Daixian County, Shanxi Province
39. Ruili County, Yunnan Province
40. Lunan County, Yunnan Province

41. Huangzhong County, Qinghai Province
42. Linhe County, Jiangsu Province
43. Fenghua County, Zhejiang Province
44. Markit County, Xinjiang Uygur Autonomous Region
45. Hami County, Xinjiang Uygur Autonomous Region
46. Xinmin County, Liaoning Province
47. Jiaonan County, Shandong Province
48. Songjian County, Shanghai
49. Longhai County, Fujian Province
50. Putian County, Fujian Province
51. Xinqiao Town, Zhangping County, Fujian Province

图书在版编目（CIP）数据

中国民间风俗画／《中国民间风俗画》 编委会编. －北京: 外文出版社，2002.5
（中华风物）

ISBN 7-119-03028-0

Ⅰ．中… Ⅱ．中… Ⅲ．农民画: 风俗画 – 作品集 – 中国 – 现代 Ⅳ.J229
中国版本图书馆 CIP 数据核字(2002)第 017882 号

"中华风物"编辑委员会

顾问: 蔡名照　赵常谦　黄友义　刘质彬
主编: 肖晓明
编委: 肖晓明　李振国　田　辉　呼宝珉　房永明　曹振峰　焦勇夫
　　　王树村　杨先襄　靳之林　胡开敏　崔黎丽　李寸松　田福会
　　　劳崇聘　于　健　曾晓田　魏建华　王　红　周大光　兰佩瑾

摄　　影: 许　涿　傅春来
翻　　译: 喻璠琴
设　　计: 元　青
责任编辑: 兰佩瑾

中国民间风俗画

ⓒ 外文出版社
外文出版社出版
（中国北京百万庄大街 24 号）
邮政编码：100037
外文出版社网页：http://www.flp.com.cn
外文出版社电子邮件地址：info@flp.com.cn
sales@flp.com.cn
北京大容彩色印刷有限公司印刷
中国国际图书贸易总公司发行
（中国北京车公庄西路 35 号）
北京邮政信箱第 399 号 邮政编码 100044
2002 年(24 开)第一版
2005 年第一版第二次印刷
（英文）
ISBN 7-119-03028-0/J・1581（外）
05800(平)
85-E-525P